W9-DGS-766

What do you suppose?

by Nora Leone & illustrated by Kara Leone

This book is dedicated to my muses...
Christina & Anna

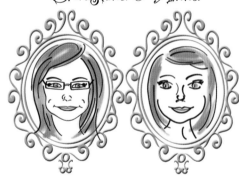

Portraits by Anna Leone Shipley

Edited by Jeanette West

Copyright 2010 by Nora Leone, Kara Leone and Higher Ground Press, LLC

Higher Ground Press, LLC
info@highergroundpress.com

ISBN: 978-0-9766062-4-6

[1. Juvenile Literature; 2. Animals; 3. Clothing, 4. Art, 5. Humor, 6. Family, 7. Gifts]
PRINTED IN KOREA

What do you suppose?

If animals wore clothes,
how would they look,
do you suppose?

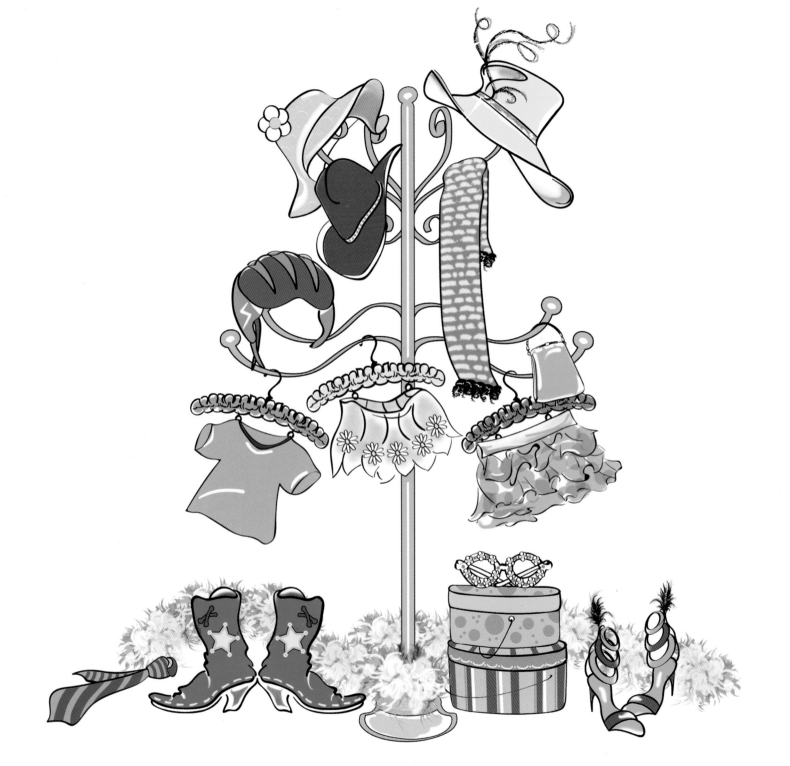

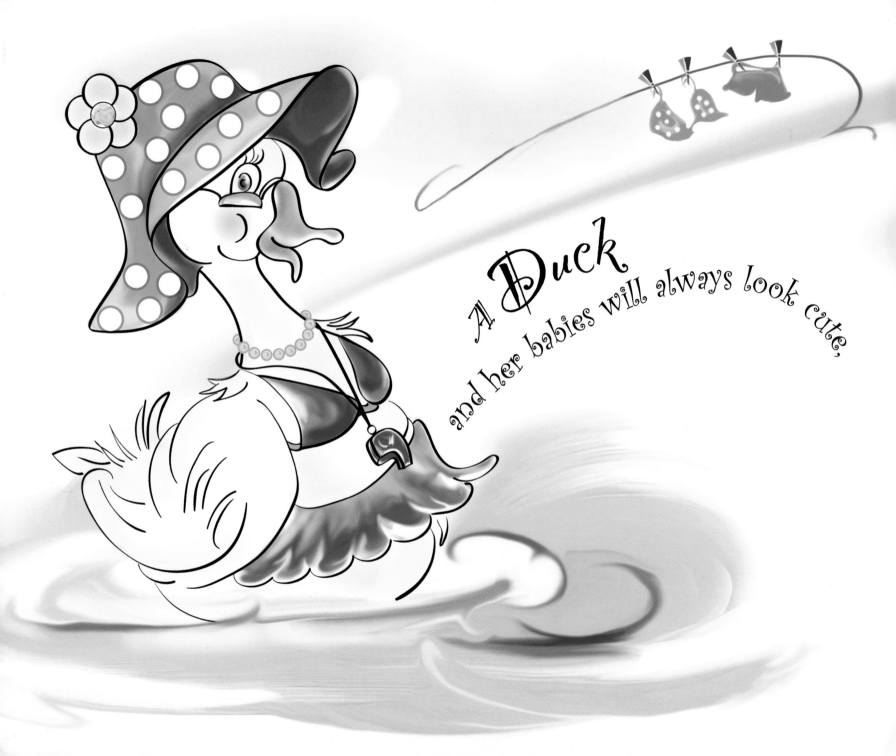

A Duck
and her babies will always look cute,

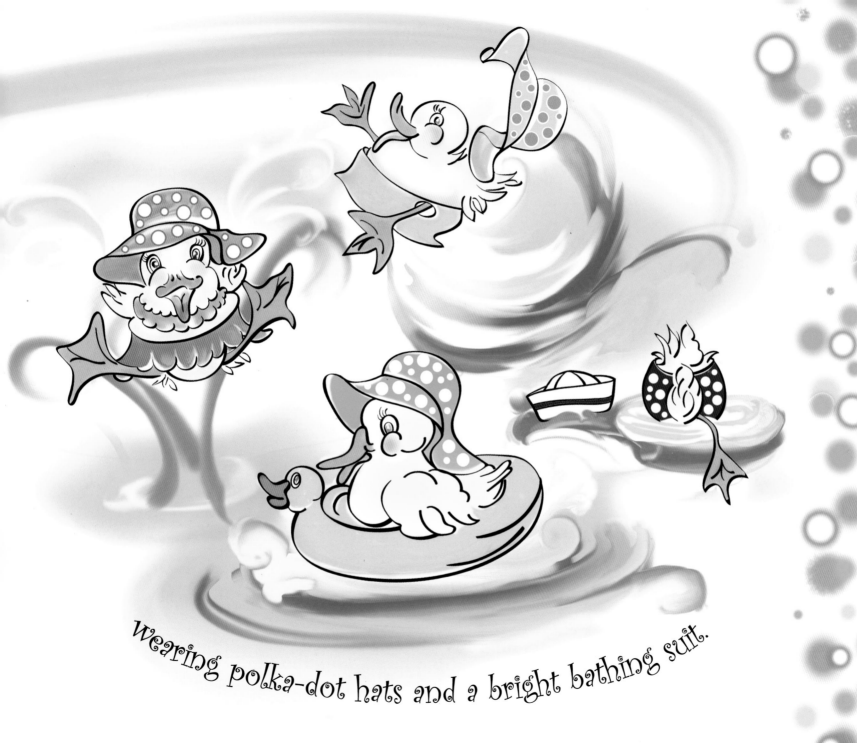

wearing polka-dot hats and a bright bathing suit.

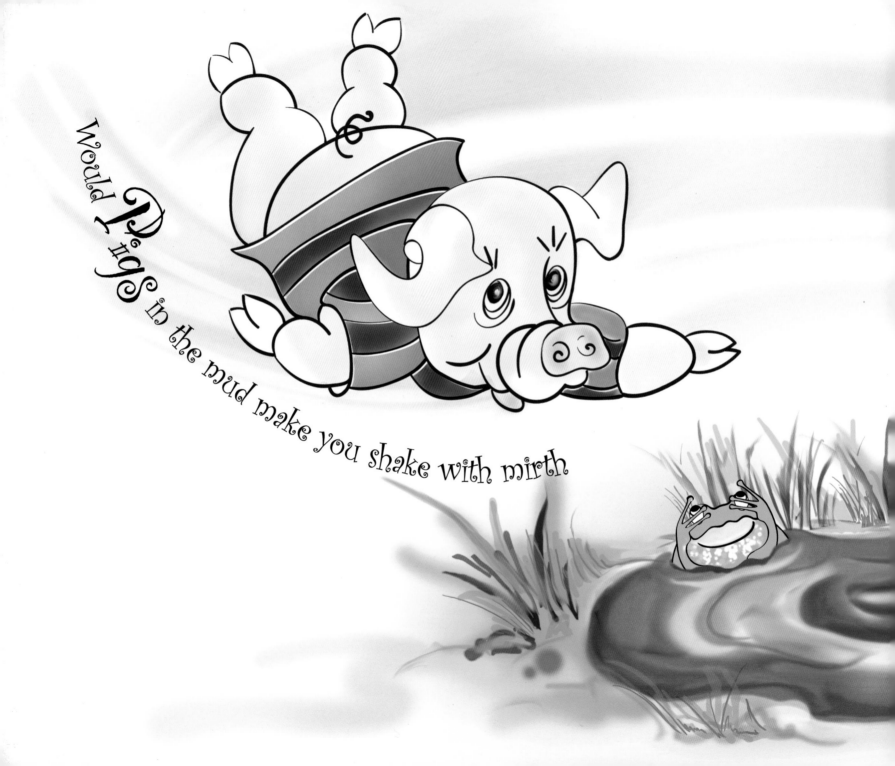

Would Pigs in the mud make you shake with mirth

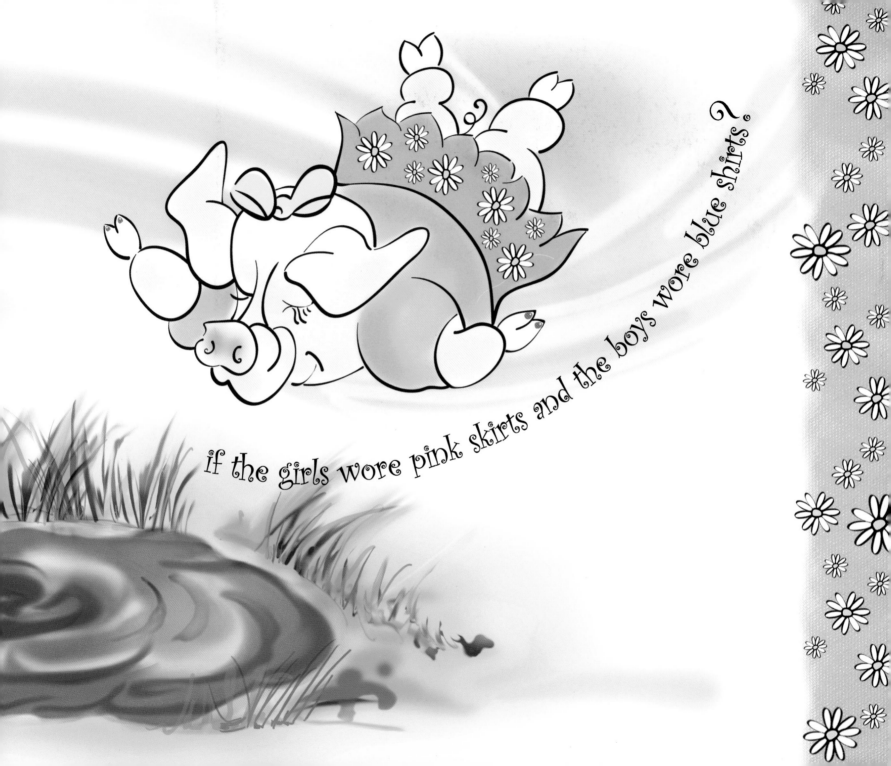

If the girls wore pink skirts and the boys wore blue shirts?

Monkeys that swing and fly through the trees, usually do whatever they please...

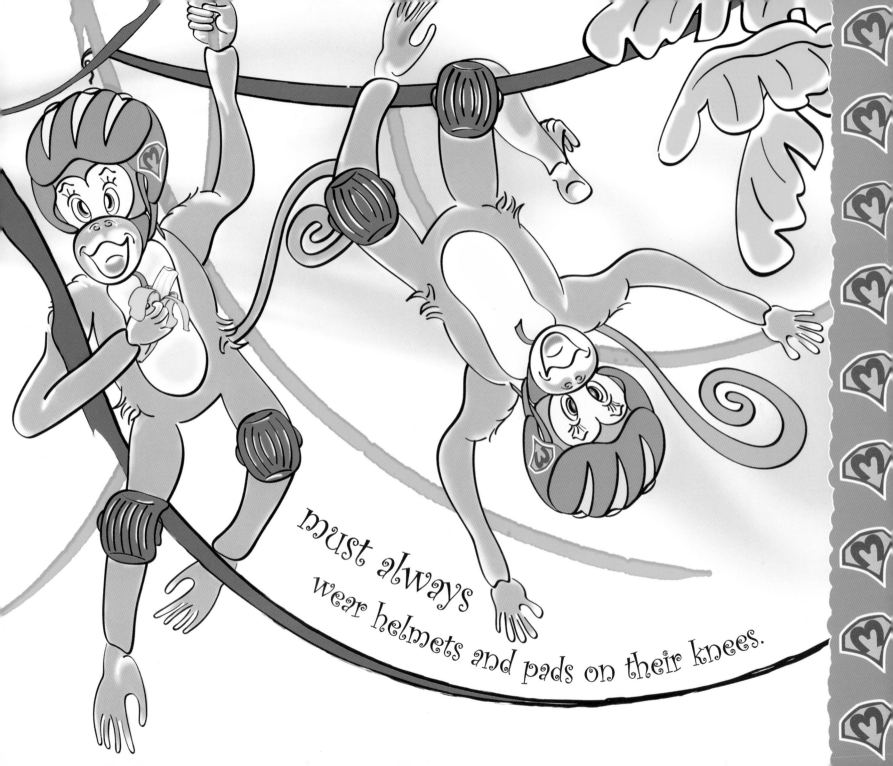

must always wear helmets and pads on their knees.

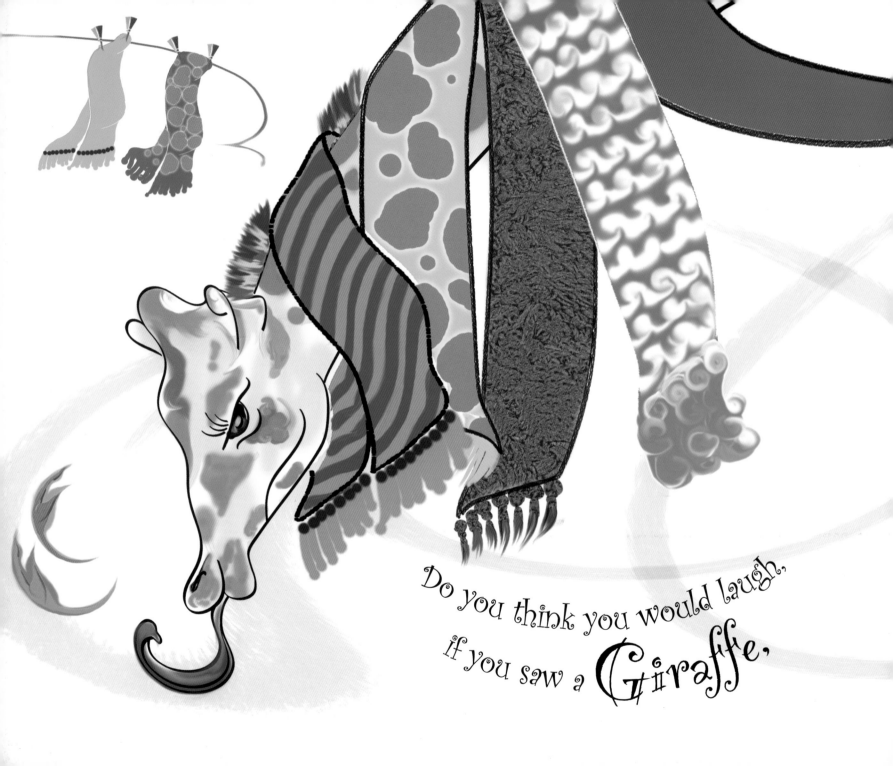

Do you think you would laugh,
if you saw a Giraffe,

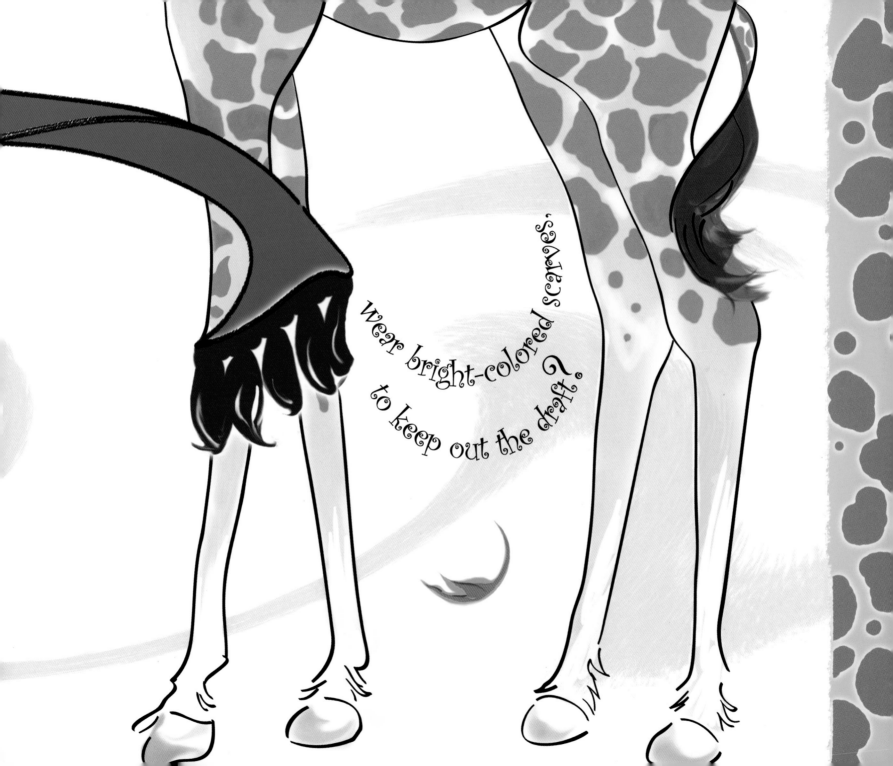

wear bright-colored scarves,
to keep out the draft.

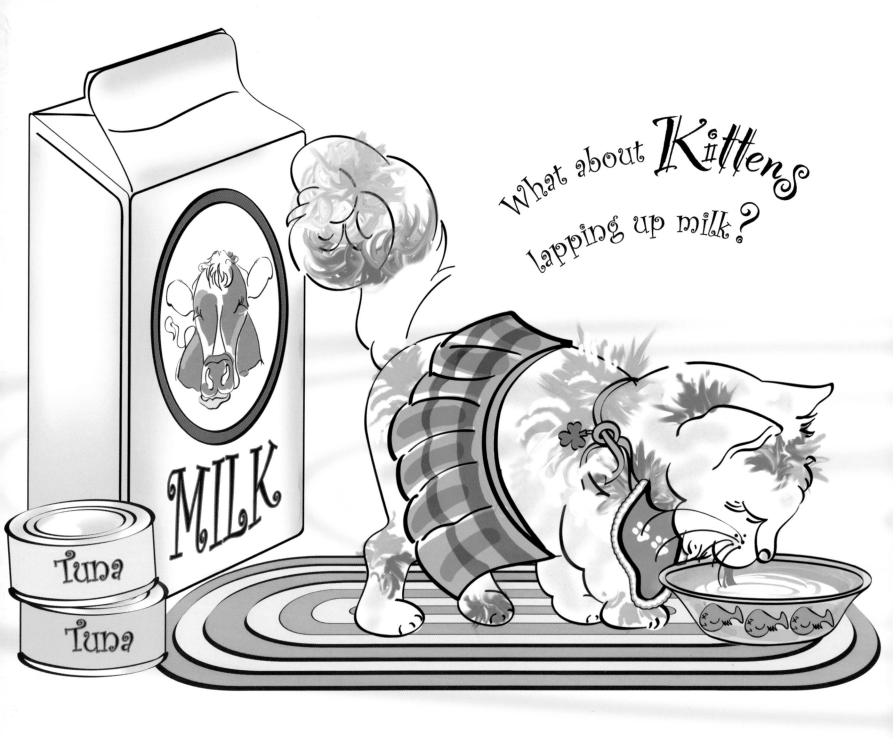

What about Kittens lapping up milk?

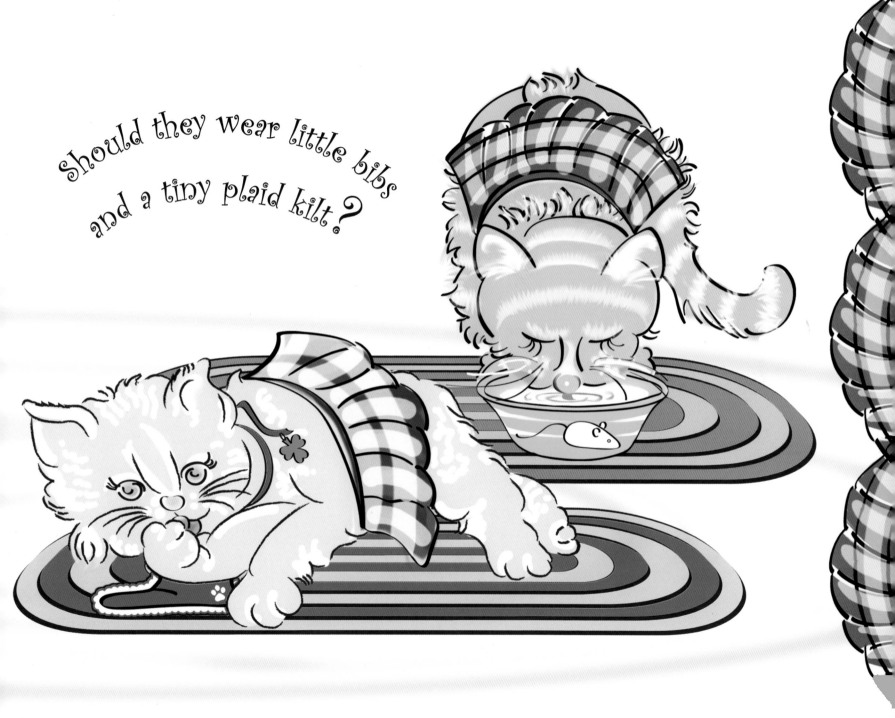

Should they wear little bibs and a tiny plaid kilt?

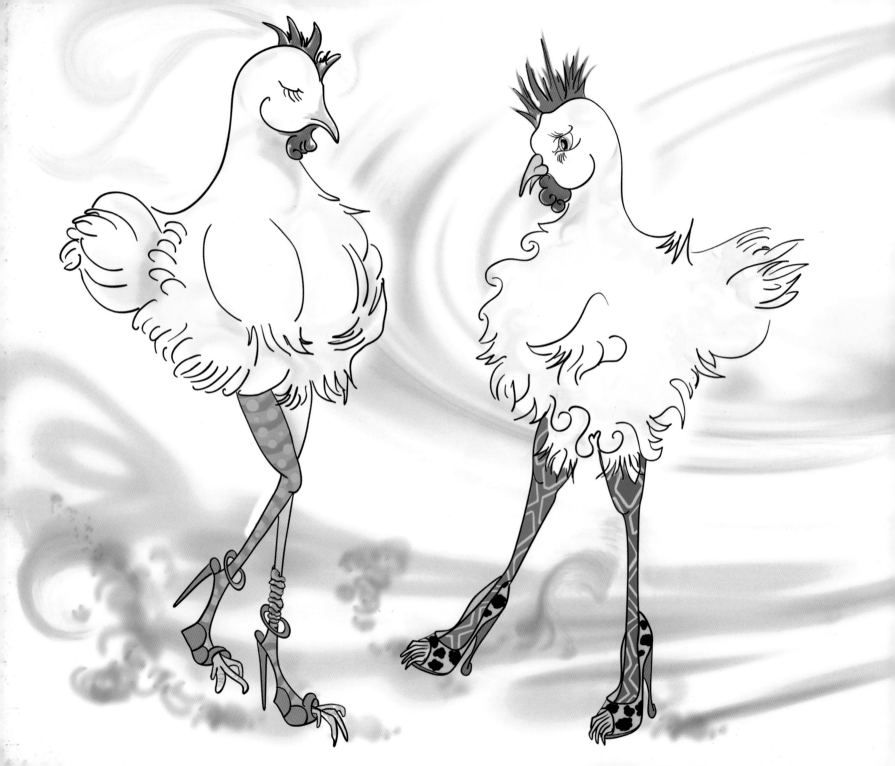

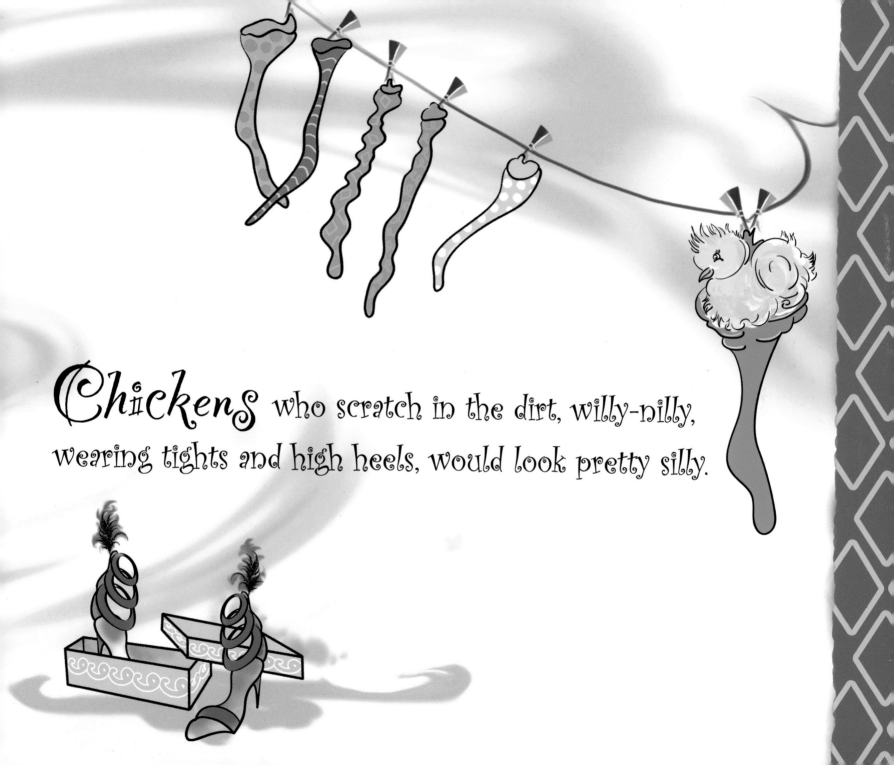

Chickens who scratch in the dirt, willy-nilly, wearing tights and high heels, would look pretty silly.

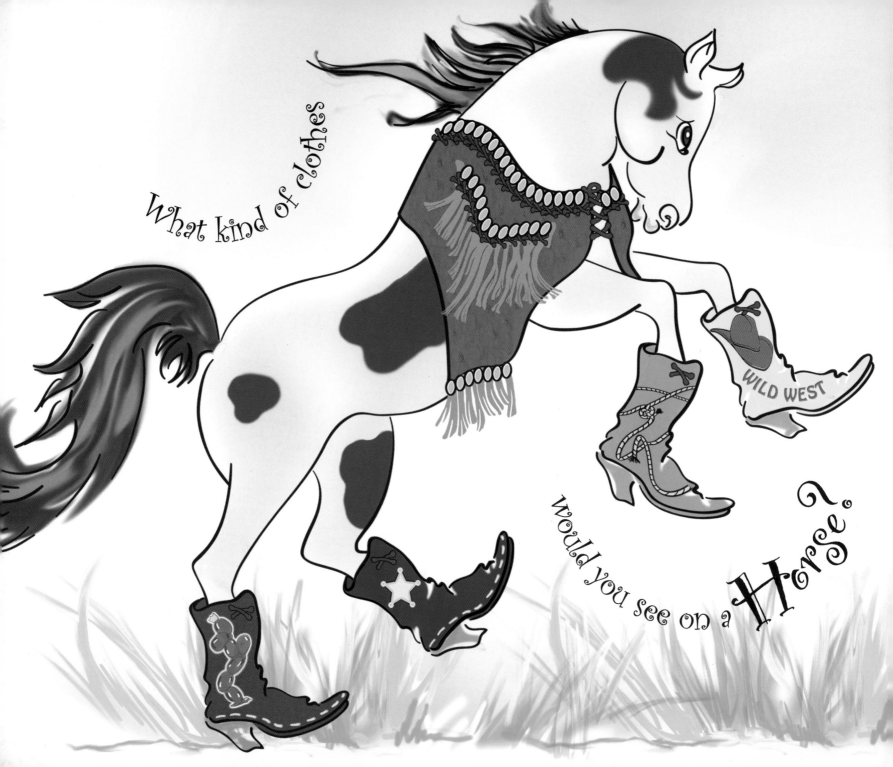

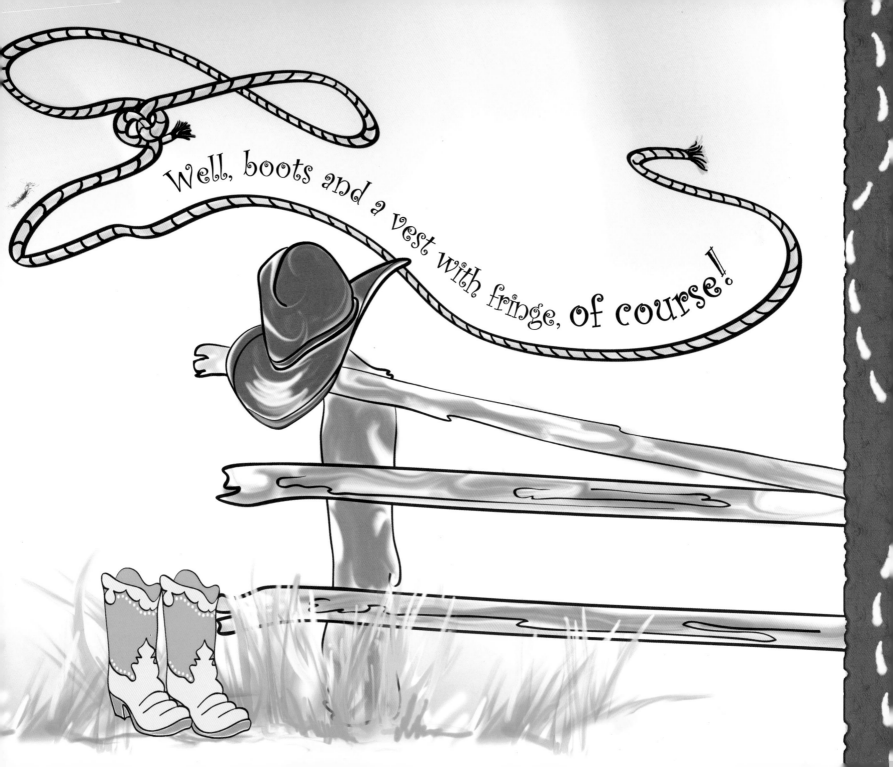

Well, boots and a vest with fringe, of course!

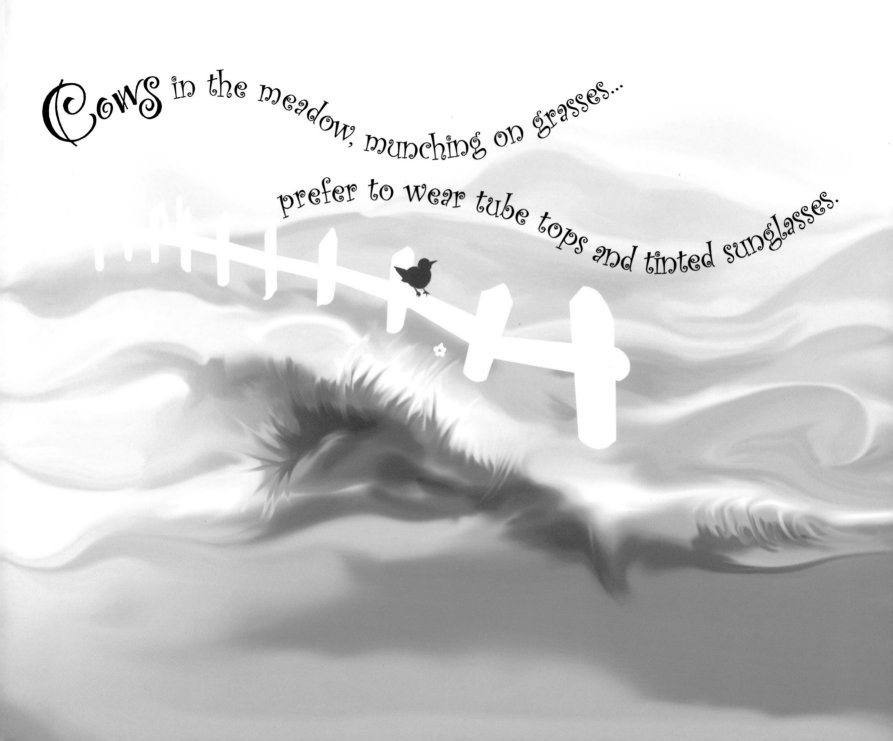

Cows in the meadow, munching on grasses... prefer to wear tube tops and tinted sunglasses.

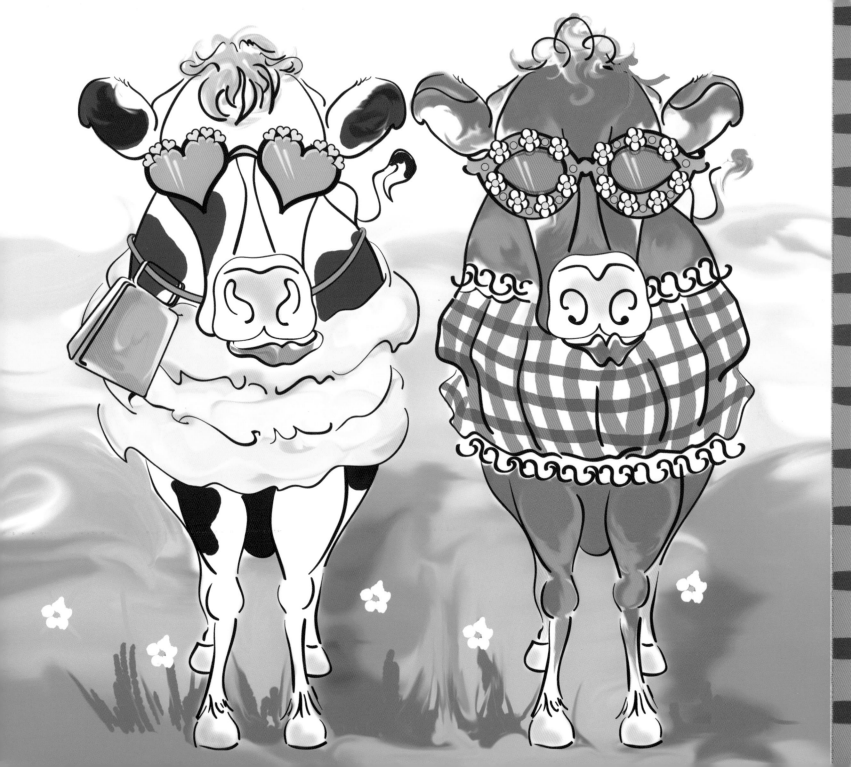

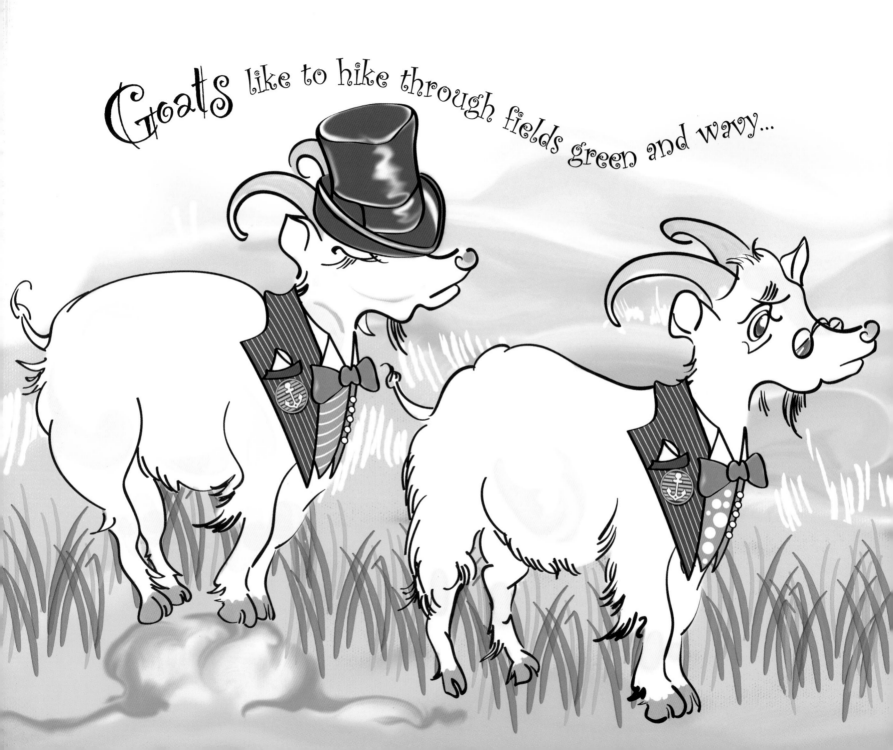

Goats like to hike through fields green and wavy...

and never look better when dressed all in navy.

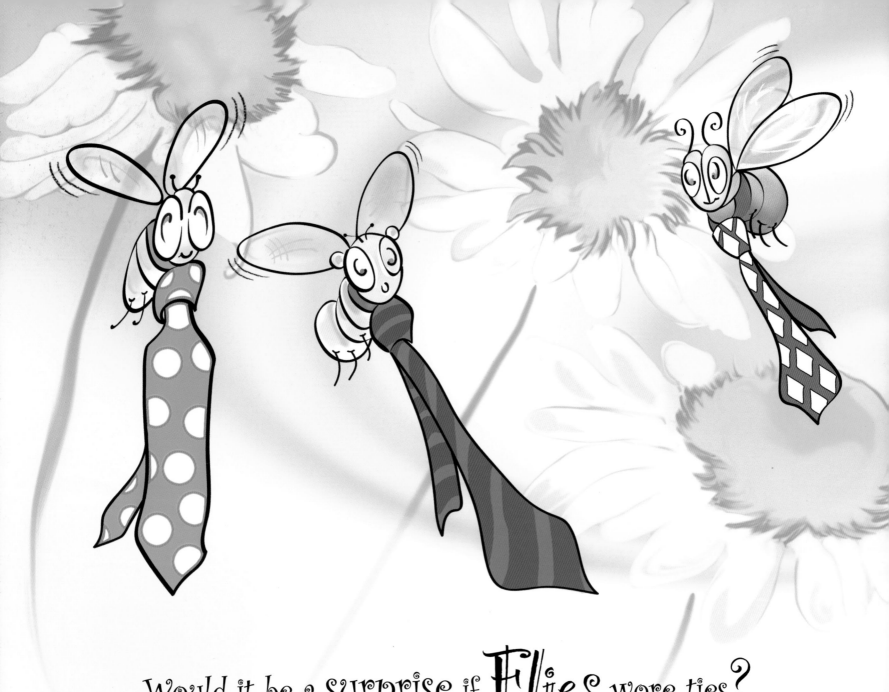

Would it be a surprise if **Flies** wore ties?

That would certainly make you roll your eyes!

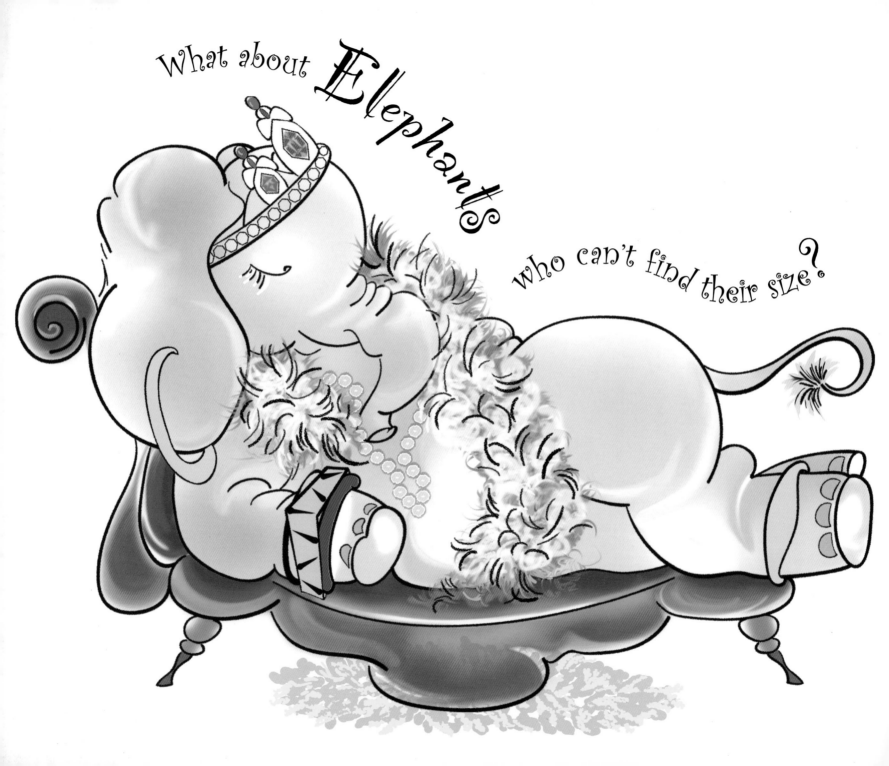

They learn very young to accessorize!

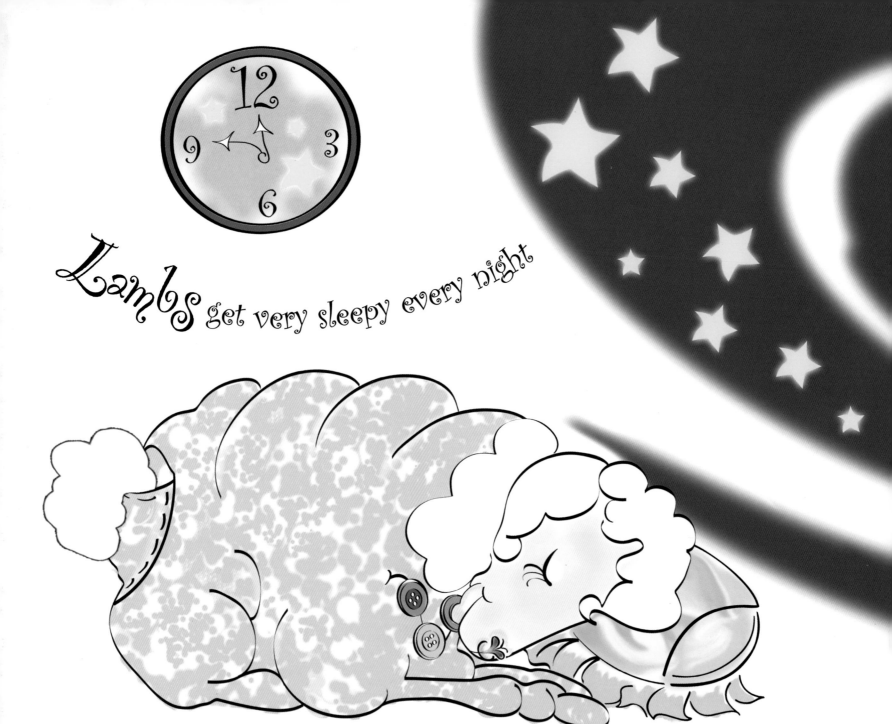

Lambs get very sleepy every night

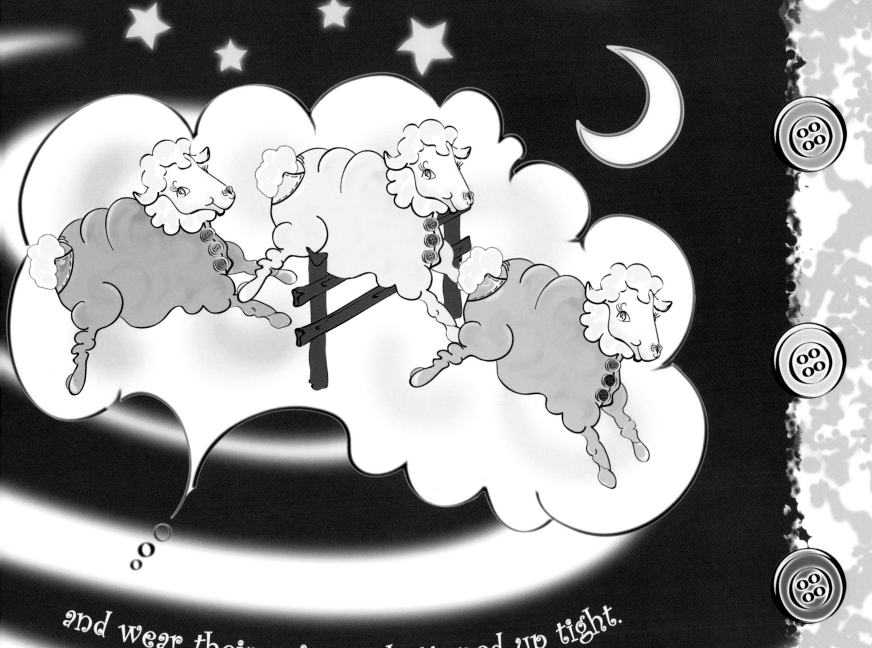

and wear their pajamas, buttoned up tight.

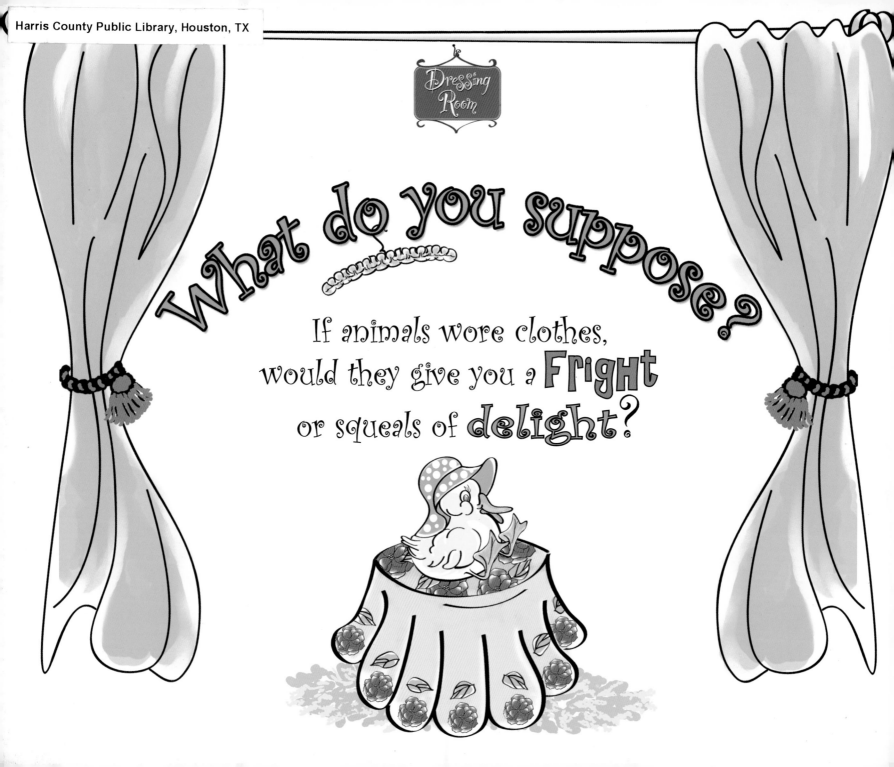

What do you suppose?

If animals wore clothes,
would they give you a **Fright**
or squeals of **delight**?